HOW TO DRAW
SPACECRAFT

Emma Fischel and Anita Ganeri

Designed by Mike Pringle, Steve Page,
Brian Robertson, Richard Maddox,
Kim Blundell and Chris Gillingwater

Illustrated by Mike Pringle, Gary Mayes,
Guy Smith, Martin Newton, Kim Blundell
and Kuo Kang Chen

Contents

About this book

This book shows you how to draw lots of different things associated with space. As well as spacecraft and other space machines, you can see how to draw planet landscapes, aliens, astronauts and even future worlds in space.

Space machines

In this book there are many ideas for drawing real space machines, from rockets and space telescopes to satellites and space stations. You can see how to use similar ideas to draw imaginary spacecraft. There are also suggestions for drawing robots and Unidentified Flying Objects (UFOs).

See page 6 for this Soyuz rocket.

This starship is on page 18.

There are all kinds of UFOs on pages 28-29.

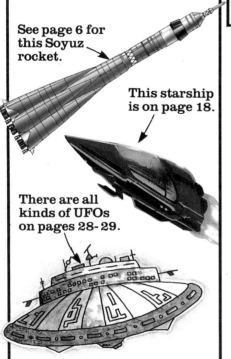

Drawing backgrounds

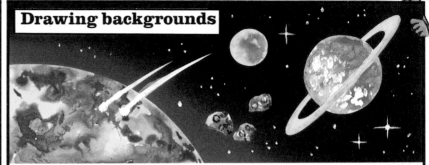

A dramatic background can really help make your picture stand out on the page. There are many suggestions for ways of creating atmospheric backgrounds, such as using the comets and meteors on pages 8-9 or planets from page 10.

Fantasy drawing

As space is still largely unexplored, there is plenty of scope for using your imagination to create pictures of life in the future. Pages 18-21 show what life might be like on a planet in the 21st century. On pages 24-27 you can see examples of fantasy and comic strip art done by science fiction artists, with tips on drawing your own fantasy pictures.

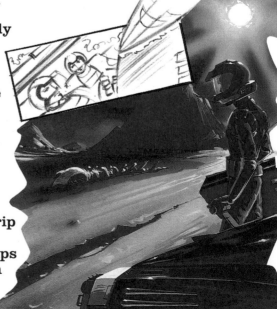

Drawing tips

Drawing in stages

Many of the pictures have step-by-step outlines to help you draw them. Sketch all the outlines in pencil first.

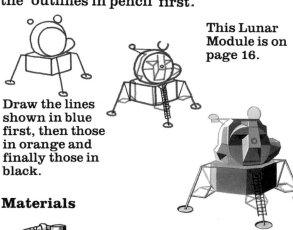

This Lunar Module is on page 16.

Draw the lines shown in blue first, then those in orange and finally those in black.

Materials

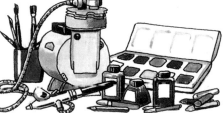

Airbrushing is explained on pages 6 and 10.

There are many suggestions for coloring materials to use. Some pictures are done with an airbrush. Airbrushes used by professionals can be expensive but you can buy cheaper models from art shops.

Professional techniques

This book gives many examples of techniques used by designers to show how parts of a space machine work or fit together. By following the simple explanations you can see how to give your drawings a really professional look.

There are cutaways on pages 12 and 14-15.

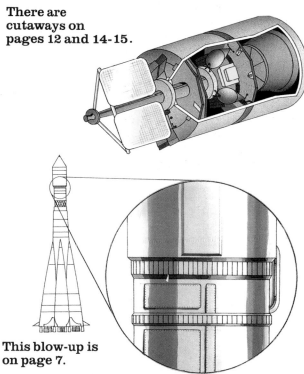

This blow-up is on page 7.

Mixing pictures

You could combine realistic and fantasy pictures from this book to create original space scenes. In this picture, for example, realistic astronauts come face to face with an alien on an imaginary planet.

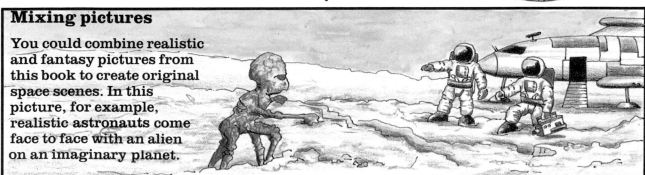

Rockets

On the following four pages there are many different kinds of rockets to draw, from the first rocket to take men to the Moon, to the Space Shuttle. You can also find out about coloring and design techniques used by professional artists.

Drawing a rocket

The rocket on the right can be broken down into fairly simple shapes. Use the steps below to help you draw it. Sketch the outlines in pencil first so you get the shapes right. Make the rocket any size you like.

1 Draw the lines shown in pencil first. These are called construction lines. They will help you position the shapes correctly and make them the right size in relation to each other. Next, draw the lines shown in blue.

Construction lines are just a guide, not part of the finished picture.

2 Draw in the lines shown in orange. Then add the details shown in black. Go over the finished outline in fine black felt tip pen, then erase the construction lines.

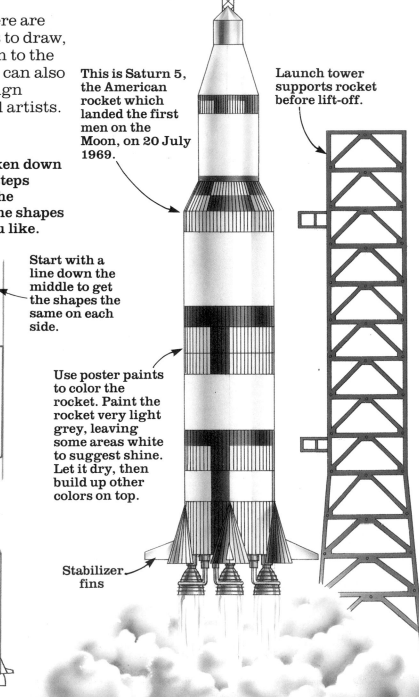

This is Saturn 5, the American rocket which landed the first men on the Moon, on 20 July 1969.

Launch tower supports rocket before lift-off.

Start with a line down the middle to get the shapes the same on each side.

Use poster paints to color the rocket. Paint the rocket very light grey, leaving some areas white to suggest shine. Let it dry, then build up other colors on top.

Stabilizer fins

Using a grid

If you want to copy a spacecraft picture from a magazine, book or photograph but would like to make it a different size from the original, try this grid method.

1 Draw a grid of equal-sized squares on tracing paper. Make the grid big enough to cover the picture you want to copy.

2 Put the grid over the picture. Draw another grid on a sheet of paper. Make the squares bigger than those on the tracing paper grid to enlarge the picture, or smaller to reduce it.

3 Look at each square on the tracing paper grid and copy the shape in it on to the same square on your second grid. Lastly, erase the grid lines.

The Space Shuttle

The first Space Shuttle was launched by the USA in 1981. A Shuttle takes off like a rocket but lands horizontally, like a plane. Its fuel tanks are jettisoned (released) once the fuel is used up. To draw the picture below, first copy the shape in the box.

Fuel tank

Shuttle part returns to Earth.

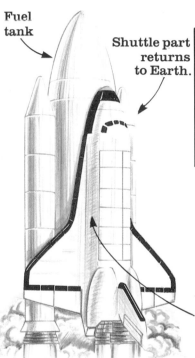

Color the Shuttle in pencil crayons, using darker shading to show its rounded shape.

This way of shading using short, slanting lines is called hatching.

Cartoon rockets

To draw these cartoon rockets, copy the shapes in pencil then go over the outlines in black felt tip pen. Use bright colors to fill in the shapes.

 Rockets need to travel very fast to go into space. To do this, they must reach a speed of at least 40,000km/h.

If a rocket does not go fast enough, it falls back to Earth.

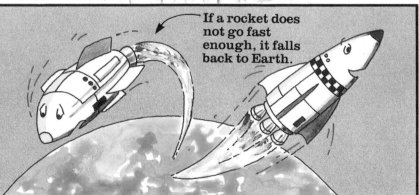

5

Drawing a Soyuz rocket

This picture is of a Russian Soyuz rocket. Soyuz has been used to launch manned space capsules into orbit. Use the steps below to help you draw the rocket.

The picture has been airbrushed. Airbrushing is a technique often used by professional artists. You can see how it is done in the box below.

Space capsule

1 Pencil in construction lines to help position the parts of the rocket.* Draw the shapes shown in blue. 2 Next, draw the shapes shown in orange, then those shown in black.

A combination of pale and darker streaks shows the shine on the body and makes the rocket look 3-dimensional.

Launch section

The first Soyuz rocket was launched on 23 April 1967.
The latest Soyuz was launched on 7 June 1988.

Fine black lines make details stand out clearly.

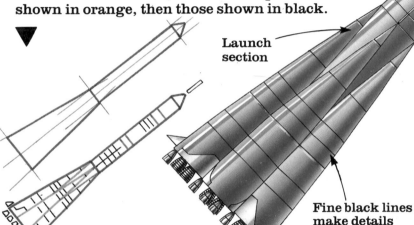

Using an airbrush

Artists use airbrushing to produce pictures that look almost like photographs.

An airbrush looks like a fat fountain pen with a tube attached to it. Air is pushed through the tube and forces paint out of a nozzle at the end of the airbrush. The air flow must be regular so the paint flows smoothly.

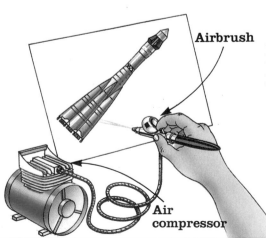

Airbrush

Air compressor

Airbrushing is popular with artists who draw machines. It is good for showing a smooth metallic finish on a machine with different tones of the same color. An airbrush can also produce fine lines and solid blocks of even color.

Blow-ups

The picture below shows a blow-up. Professional designers use this technique to pull out one part of a machine and show it in a lot of detail. To draw this blow-up, follow the steps below.

1 First draw the outline of the whole rocket in pencil. Draw a small circle round the part to be blown up.

2 Draw two straight lines extending from the circle, then draw a larger circle between them.

This blow-up shows details of the Russian Vostok spacecraft.

You could use a different shape to frame the blow-up, such as a square or rectangle.

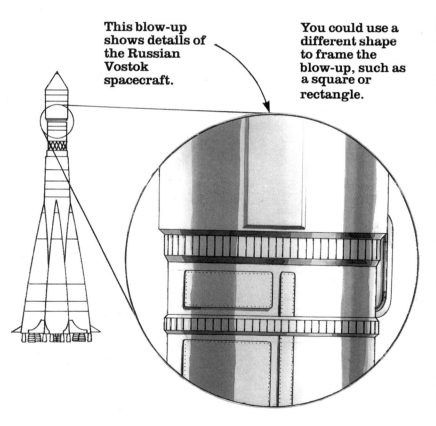

3 Next, fill in the details of the part that is blown up inside the circle frame.

4 Go over the pencil lines in black felt tip pen. Then use blue and grey watercolor to paint the blow-up.

Exploded drawings

Exploded drawings are used to show how parts of a machine fit together. Parts are drawn slightly away from their true position to show how they are joined to each other.

This picture is of Apollo 11.

Arrows show exactly where the parts fit together.

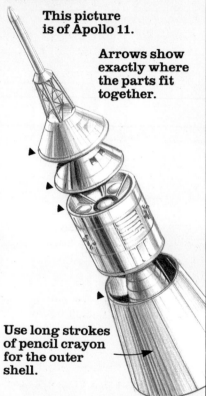

Use long strokes of pencil crayon for the outer shell.

Try working out your own exploded drawings using the ideas above. You could use some of the machines shown later in this book, such as the space telescope on page 13 or the lunar module on page 16.

7

Space journey

Here you can see how to draw the various stages of a rocket's journey through space.* There are also tips on creating the dramatic background.

* See page 4 for a rocket's basic shape.

Perspective

Rocket zooming into space.

Objects look smaller the further away they are. This is called perspective.

Escape tower

Stars are grouped in giant clusters called galaxies.

Third stage

A rocket built in one piece would be too heavy to gain enough speed to enter space.

Second stage

First stage jettisoned.

Meteors are small pieces of rock. At about 80km from Earth they burn up, producing streaks of light which are called shooting stars.

First stage

A multi-stage rocket

Rockets are used to launch satellites and manned spacecraft into space. As rockets need to reach huge speeds in order to enter space (see page 5), they are built in sections, called stages. Each stage is jettisoned when its fuel is used up, making the rest of the rocket lighter and faster. The next stage's engines fire, giving the rocket more power and speed.

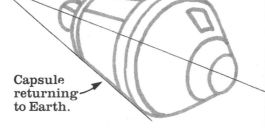

The vanishing point is the furthest point the eye can see.

Capsule returning to Earth.

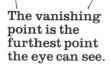

To draw these spacecraft in perspective, first draw three lines meeting at a point.

This is called the vanishing point. Draw in the shapes between the lines.

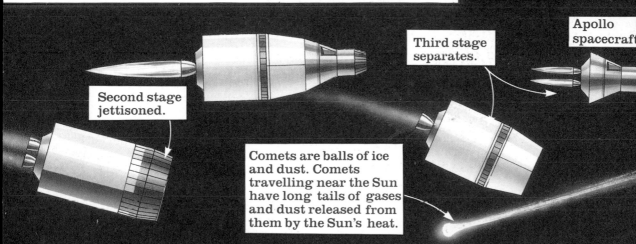

Second stage jettisoned.

Third stage separates.

Apollo spacecraft

Comets are balls of ice and dust. Comets travelling near the Sun have long tails of gases and dust released from them by the Sun's heat.

Drawing the background

Here are some suggestions for ways to color in a space background, using a mixture of watercolors and chalks on a sheet of dark blue or black paper.

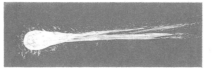

To draw star clusters, dip a brush into white paint. Flick the paint on to the paper with your finger.* Add crosses and smudges of chalk.

Draw the comets in white paint. Use a thick splotch of paint for the body. Then add quite thick, dry streaks for the tail.

To draw meteors, start by painting the shapes white. Let this dry, then add layers of light and dark brown paint on top.

*Cover up the rest of the picture to protect it from splashes.

The planets

Earth is in a part of space called the Solar System. This is made up of the Sun, nine planets which orbit it, their moons and a band of rocks called asteroids. Below you can find out more about planets and ways of drawing them.

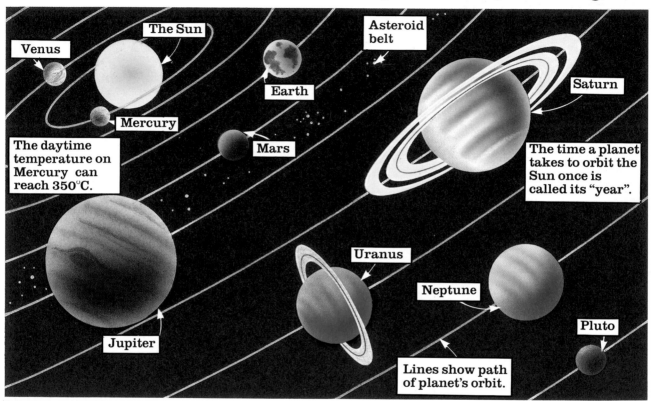

Venus

The Sun

Asteroid belt

Saturn

Earth

Mercury

The daytime temperature on Mercury can reach 350°C.

Mars

The time a planet takes to orbit the Sun once is called its "year".

Jupiter

Uranus

Neptune

Pluto

Lines show path of planet's orbit.

Professional tip

The picture above was drawn with an airbrush.* Only one color can be put on at a time so an artist uses "masks" to protect the rest of the painting that is not being sprayed.

Masks can be made of card or film, or masking fluid may be used. This is painted on and can be peeled off later. To get sharp, clear edges an artist uses a card stencil and sprays the area inside it.

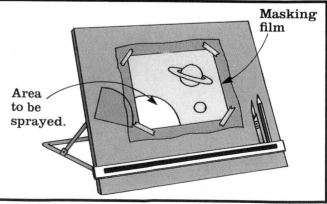

Masking film

Area to be sprayed.

Drawing the planets

If you don't have an airbrush you can achieve dramatic effects using shades of pencil crayons.

Jupiter

The red patch is a huge hurricane, about three times as big as Earth.

Use pale red and orange with darker bands on top. Add shadows round the bottom half of the planet.

Saturn

Saturn's rings are made up of millions of ice and rock particles.

Gases on Saturn's surface make bands of different colors. Show this with contrasting shades.

Uranus

Uranus takes 84 Earth years to orbit the Sun.

Uranus looks green because of clouds of methane gas swirling around it. Shade this with green and yellow.

Planetary probes

Planetary probes are unmanned spacecraft, launched into space by rockets. Cameras on board send back pictures of planets' surfaces.

Mariner

Here you can see how to draw the probe Mariner 4, which took photographs of the surface of Mars.

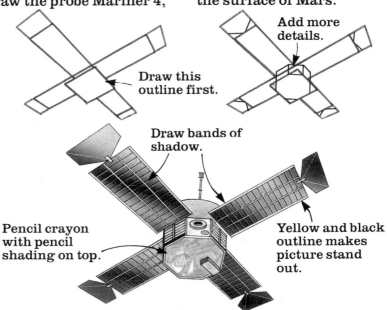

Draw this outline first.

Add more details.

Draw bands of shadow.

Pencil crayon with pencil shading on top.

Yellow and black outline makes picture stand out.

Surface of Mars

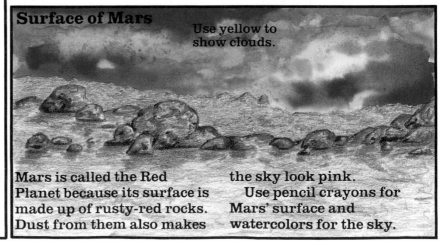

Use yellow to show clouds.

Mars is called the Red Planet because its surface is made up of rusty-red rocks. Dust from them also makes the sky look pink. Use pencil crayons for Mars' surface and watercolors for the sky.

Looking at space

A satellite is any object in space which orbits a larger object. It can be natural, like Earth which orbits the Sun, or artificial, like the ones on these pages.

Comstar 1

To draw this picture of Comstar 1, first copy the outline shapes below in pencil. Color the body with felt tip pens and add the final details with fine black lines.

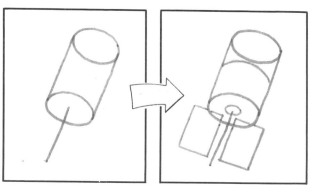

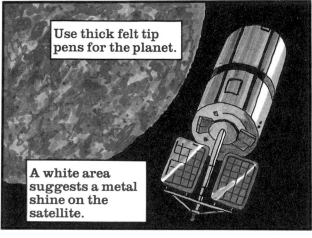

Use thick felt tip pens for the planet.

A white area suggests a metal shine on the satellite.

Drawing a cutaway

This picture is called a cutaway. Cutaways leave out part of a machine's outer shell to show what is inside it.* They are often used by spacecraft designers to show how the equipment on board is to be carried.

To draw this cutaway, pencil in the outline of the satellite's shell and draw a line round the area which will form the cutaway section. Add more details to both sections, then go over the pencil lines in black. Color the satellite with felt tip pens.

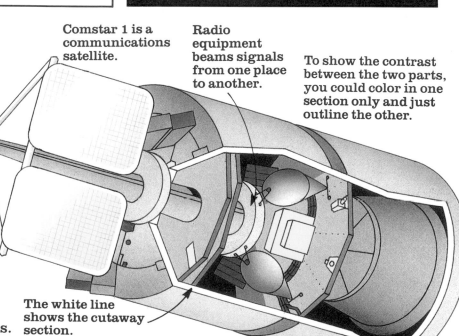

Comstar 1 is a communications satellite.

Radio equipment beams signals from one place to another.

To show the contrast between the two parts, you could color in one section only and just outline the other.

The white line shows the cutaway section.

 See how to draw a cutaway space station on page 14.

Satellites at work

Satellites are used mainly for weather forecasting and communications. They can take pictures of cloud patterns, for example, or beam television signals from one place to another.

This cartoon shows satellites which are geo-stationary (staying in a fixed place high above the Equator) and polar orbiting (circling Earth between the poles).

Draw the cartoon in pencil first, then color the satellites with bright felt tip pens and go over the outlines in black. Color Earth in green and blue felt tip pens. Add quite dry, thick white paint on top for clouds.

Polar orbiting satellite.

Geo-stationary satellite.

Arrows show position of satellites in relation to Earth.

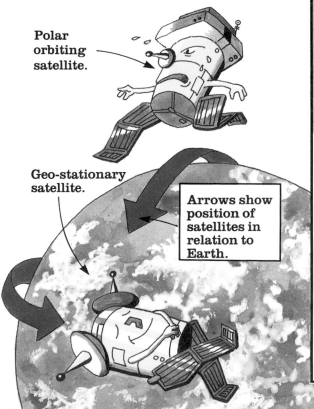

Space telescope

This is a telescope the USA plans to launch into space. It can see seven times further than any other telescope ever built.

If the telescope were in London, England it could see a coin in Frankfurt, Germany, about 700km away.

Make areas darker by drawing the dots closer together.

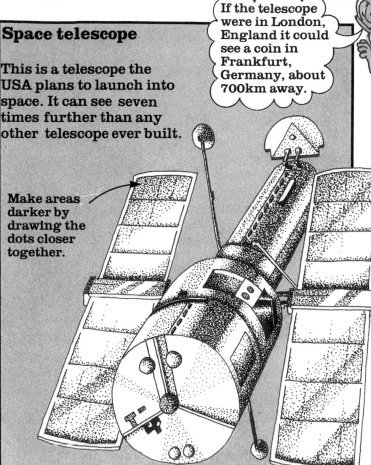

To draw the telescope, start by copying the outline shape shown on the right. Shade the body in pencil, using small dots. This technique is called stippling and is a good way of suggesting the curved surfaces of a machine.

Draw the lines shown in blue, then orange, then black.

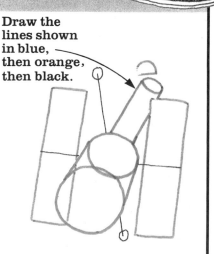

13

Inside a space station

A space station is a type of satellite launched by a rocket. It carries a crew and equipment for doing scientific research impossible to do on Earth. It also studies how people are affected by spending a long time in space.

Skylab

Skylab was launched in 1973. Among other equipment, it carried a telescope to study the Sun.

Here you can see how to draw this cutaway of Skylab by breaking it down into simple shapes. Start by copying the blue outline.

You can mix bright colors and metallic greys to make your picture stand out.

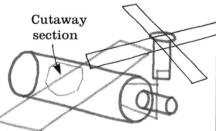

The basic body shapes are cylinders.

Next, add the lines shown in orange and black. Pencil in the outline of the part of Skylab to be cut away.

Cutaway section

Add further details from the main picture on the right. Draw over the pencil lines in black, then use poster paints or pencil crayons to color it in.

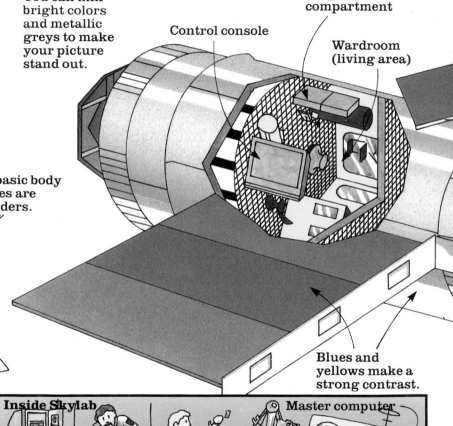

Sleeping compartment

Control console

Wardroom (living area)

Blues and yellows make a strong contrast.

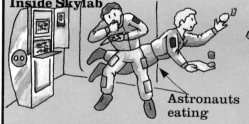

Inside Skylab

Master computer

Astronauts eating

You could use a cartoon style to draw some aspects of life on board Skylab. Use bright colors and black outlines to make the cartoons stand out.

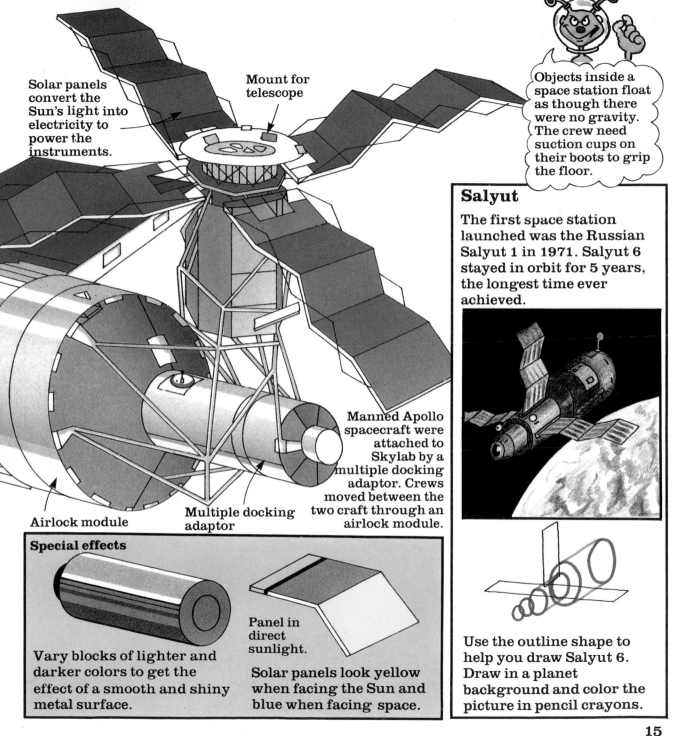

Solar panels convert the Sun's light into electricity to power the instruments.

Mount for telescope

Salyut

The first space station launched was the Russian Salyut 1 in 1971. Salyut 6 stayed in orbit for 5 years, the longest time ever achieved.

Manned Apollo spacecraft were attached to Skylab by a multiple docking adaptor. Crews moved between the two craft through an airlock module.

Airlock module

Multiple docking adaptor

Use the outline shape to help you draw Salyut 6. Draw in a planet background and color the picture in pencil crayons.

Special effects

Vary blocks of lighter and darker colors to get the effect of a smooth and shiny metal surface.

Panel in direct sunlight.

Solar panels look yellow when facing the Sun and blue when facing space.

15

On the Moon

The Moon is over 380,000km away, but it is Earth's closest neighbor in space. Since unmanned lunar probes were launched in the 1950s, man has landed on the Moon and we now know more about what it looks like. Here you can see how to draw the Moon's surface and machines which have landed on it.

Lunar Module

To enlarge this shape you could use a grid (see page 5).

The Lunar Module took astronauts from the USA Apollo spacecraft to the Moon's surface.

To draw the Lunar Module, follow the outlines above. Draw the lines shown in blue first.

Next, draw the lines shown in orange, then add the further details shown in black to your picture.

Fill in the shapes with bright blocks of color. To make the picture stand out further, you could outline it in black.

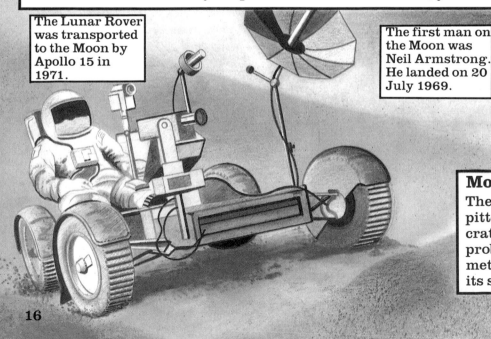

The Lunar Rover was transported to the Moon by Apollo 15 in 1971.

The first man on the Moon was Neil Armstrong. He landed on 20 July 1969.

The surface of the Moon is very dry and dusty. To get the grainy look, put a sheet of sandpaper under your picture when you color it.

Moon craters

The surface of the Moon is pitted with millions of craters. These were probably caused by meteorites crashing on to its surface.

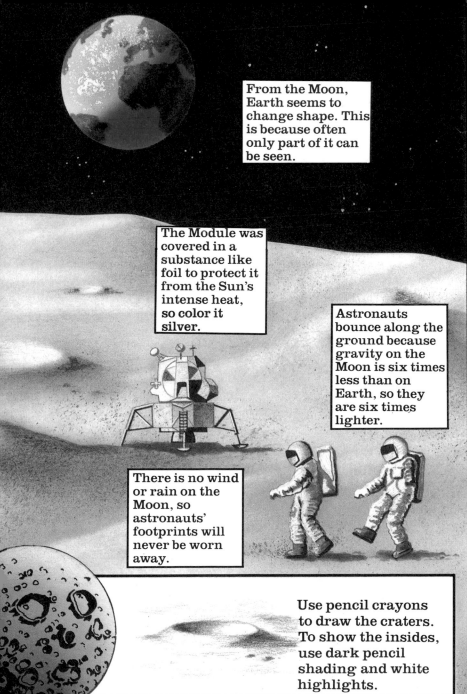

From the Moon, Earth seems to change shape. This is because often only part of it can be seen.

Spacesuits

As the Moon has no air, astronauts have to wear special suits with tanks providing them with oxygen to breathe. The suits also protect them from the cold on the Moon.

The Module was covered in a substance like foil to protect it from the Sun's intense heat, so color it silver.

Astronauts bounce along the ground because gravity on the Moon is six times less than on Earth, so they are six times lighter.

Use the outline above to help you draw this astronaut.

There is no wind or rain on the Moon, so astronauts' footprints will never be worn away.

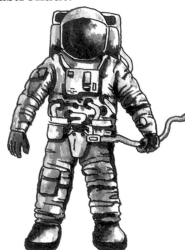

Use pencil crayons to draw the craters. To show the insides, use dark pencil shading and white highlights.

Color the spacesuit in watercolor paint. Use highlights to show the shine on the material.

The future in space

This picture shows what life might be like on an imaginary planet in the year 2090 AD. Although this is a fantasy picture, many of the things in it are based on scientific theory about advances that may be possible by then.

The picture is done in airbrush and gouache (a type of poster paint used by professional artists). Over the page there are suggestions for drawing some of the objects shown here and tips on creating some of the special effects.

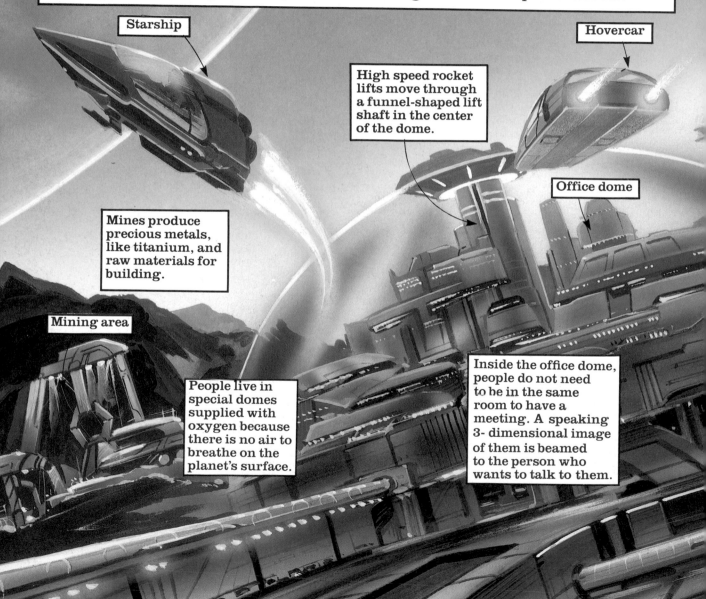

Starship

Hovercar

High speed rocket lifts move through a funnel-shaped lift shaft in the center of the dome.

Office dome

Mines produce precious metals, like titanium, and raw materials for building.

Mining area

People live in special domes supplied with oxygen because there is no air to breathe on the planet's surface.

Inside the office dome, people do not need to be in the same room to have a meeting. A speaking 3-dimensional image of them is beamed to the person who wants to talk to them.

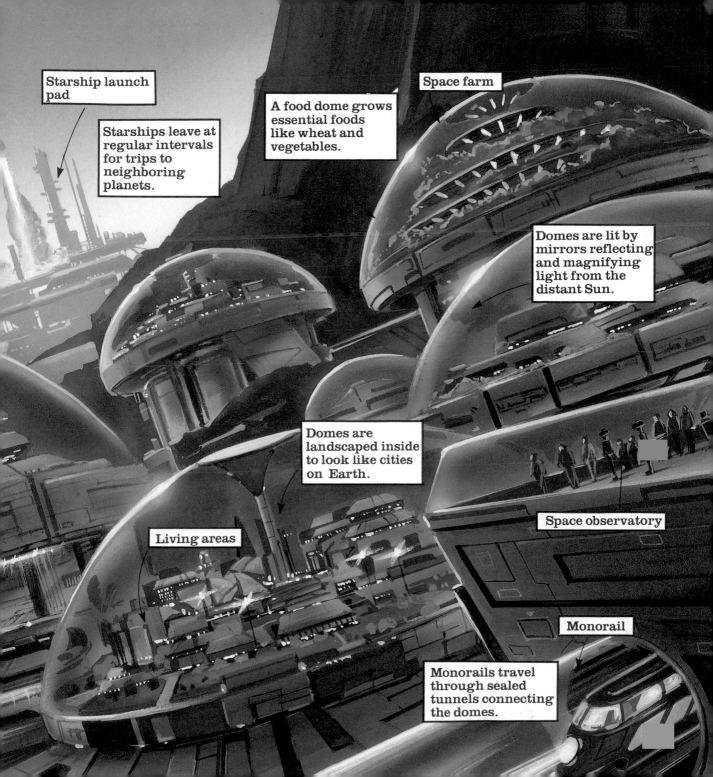

Starship launch pad

Starships leave at regular intervals for trips to neighboring planets.

A food dome grows essential foods like wheat and vegetables.

Space farm

Domes are lit by mirrors reflecting and magnifying light from the distant Sun.

Domes are landscaped inside to look like cities on Earth.

Living areas

Space observatory

Monorail

Monorails travel through sealed tunnels connecting the domes.

Transport in the future

Here are three forms of transport that might be used on a planet in the 21st century. Follow the outlines and the tips below to help you draw these vehicles.

Hovercar

Color the hovercar in soft pencil crayons, adding a logo to its roof.*

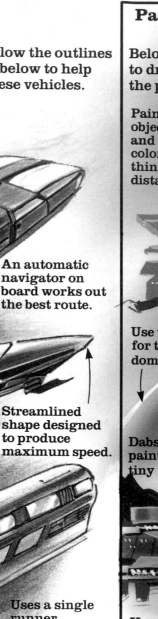

Logo

An automatic navigator on board works out the best route.

Starship

Leaving white gaps along the body helps give an impression of great speed.

Streamlined shape designed to produce maximum speed.

Monorail

Suggest the shiny glass of the windows by using blue and white crayons.

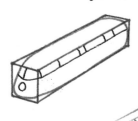

Uses a single runner instead of wheels.

For the background use long crayon strokes. Smudge the colors with your finger to blend them together.

Painting tips

Below are some tips on how to draw the space scene on the previous page.

Paint nearer objects darker and use paler colors for things in the distance.

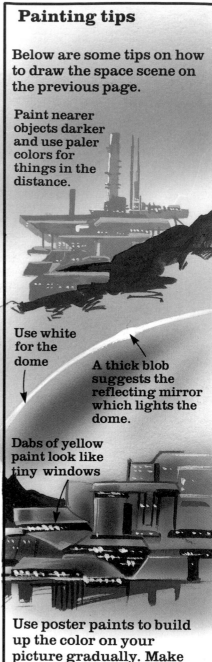

Use white for the dome

A thick blob suggests the reflecting mirror which lights the dome.

Dabs of yellow paint look like tiny windows

Use poster paints to build up the color on your picture gradually. Make sure each layer of paint is dry before adding the next.

Drawing a robot

By the year 2090 AD robots could be a common feature in the home. To draw this robot, start by copying the shapes below.

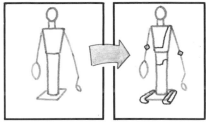

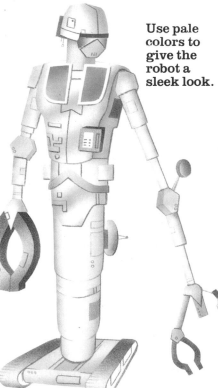

Use pale colors to give the robot a sleek look.

Go over the details in black to show all the parts of the robot clearly.

Inside a 21st century house

This picture shows what a typical room might look like in 2090. Draw the basic shapes in the room before adding further details. Use poster paints to color it, with pencil crayon lines on top for extra shading.

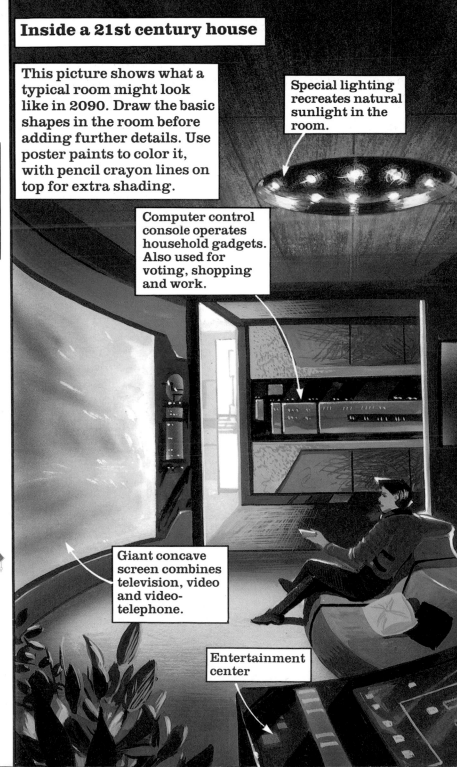

Special lighting recreates natural sunlight in the room.

Computer control console operates household gadgets. Also used for voting, shopping and work.

Giant concave screen combines television, video and video-telephone.

Entertainment center

Space aliens

Space travel has not been able to prove that life exists on other planets — yet. As no-one knows what alien life forms would look like, you can make them as unusual as you like. You could base them on recognizable human figures or make them completely imaginary. Here are some ideas to start you off.

Cartoon aliens

These aliens are based on the outline shapes in the box below. First copy each outline, then draw in the rest of the body. Go over the outline in black, then color the aliens with felt tip pens, using a mixture of colors and patterns.

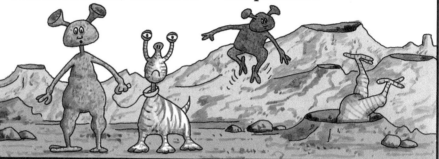

Alien from Venus

Based on what is known of the planets, you can work out the kind of features an alien might need to have in order to live on one of them.

This alien has an insulating shell to protect it from the extreme heat on Venus. On the right you can see how to get a scaly effect on the alien's body.

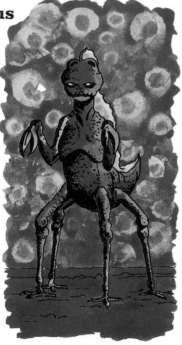

Drawing alien skin

Use a watercolor base for this skin. Let it dry, then draw black scales.

Use pencil crayons, leaving parts of the veins uncolored so they look bulgy.

Use a pencil crayon base. Add scales on top in fine black or brown felt tip pen.

Use pencil crayons, adding hairs in brown felt tip pen to get a bristly effect.

Humanoid aliens

An alien might well show some physical similarities to a human being. But on a planet where conditions are different from Earth, its limbs and senses may have developed in strange ways. Here you can see some suggestions for drawing humanoid aliens.

Metal Martian

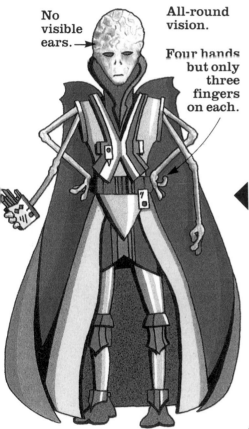

No visible ears. →

All-round vision.

Four hands but only three fingers on each.

To draw this alien, first use a pencil to copy the blue outline above on the left, then add the lines shown in orange. Fill in the shapes of the arms and legs and erase the pencil lines inside them. Copy the alien's clothes from the main picture and draw in its features. Go over the outline in black.

You can see how to color the alien's skin on the opposite page. Color its clothes with felt tip pens. Show shadows on its cloak by using a darker shade of the base color.

In 1955, someone claimed to see a goblin-like alien peering through a farmhouse window in Kentucky, USA. It was only a meter high, with pointed ears and big, bulging eyes.

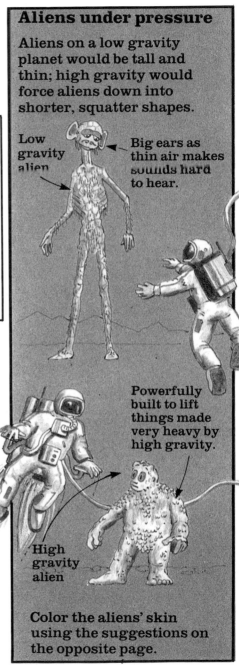

Aliens under pressure

Aliens on a low gravity planet would be tall and thin; high gravity would force aliens down into shorter, squatter shapes.

Low gravity alien →

Big ears as thin air makes sounds hard to hear.

Powerfully built to lift things made very heavy by high gravity.

High gravity alien

Color the aliens' skin using the suggestions on the opposite page.

Science fiction art

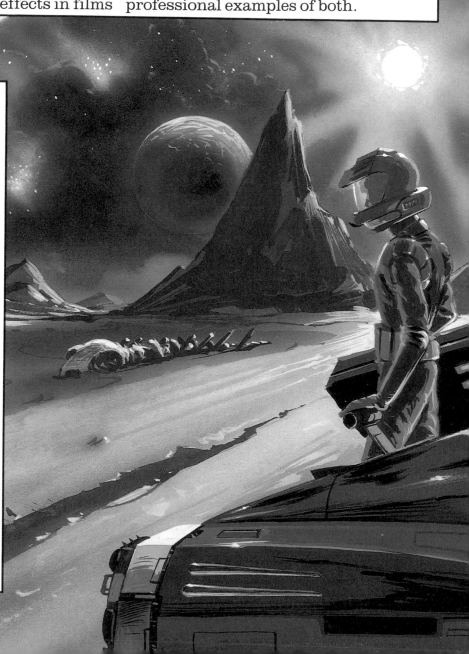

Science fiction art has become a very popular form of illustration. It is used a lot in magazines and books, and as the basis for creating special effects in films and on television. The two main types of science fiction illustration are fantasy art and comic strip art. Here you can see professional examples of both.

Fantasy art

Fantasy art shows imaginary visions of the future or other worlds. Artists often use a realistic drawing style, with unusual colors and effects to create pictures with plenty of atmosphere. Sometimes the scenes are rather frightening, but they can also be optimistic and even comic.

Fantasy artists mainly use airbrush and gouache to get subtle tones and dramatic shadows.

In this picture, the artist, Gary Mayes, uses a dramatic sky to contrast with an almost deserted planet. The loneliness of the planet is emphasized further by a single figure looking at the skeleton of a long-dead alien creature.

There are other examples of fantasy art on pages 18-21, with tips on how to create some of the professional effects.

Comic strip art

The comic strip below is a story about Dan Dare, the space hero who first appeared in Eagle magazine in 1950. The stories have been drawn by many artists, the best known being Frank Hampson and Frank Bellamy, who redesigned Dan Dare in 1960. The modern Dan Dare strip below was drawn by John Higgins for Eagle Annual in 1987.*

Short captions set the scene.

Close-ups are mixed with longer views.

The planet is seen from an unusual viewpoint.

Thought and speech bubbles are often used together.

The background scene continues behind the whole strip.

Here the reader sees the villain from the hero's viewpoint.

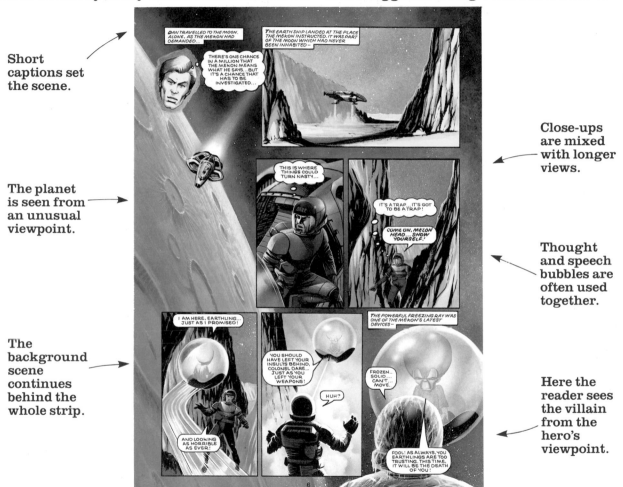

The artist credited with giving the early Dan Dare strips their distinctive look is Frank Bellamy. His way of working was unusual as, instead of sketching in pencil, he drew almost immediately in ink, using only faint, rough pencil lines as a guide. He drew in the frames after the strip was finished, sometimes using circles or zig-zags instead of box frames, or even leaving them out completely.

Drawing a comic strip

Here you can see how to build up your own science fiction comic strip, starting from a basic story idea. There are also tips for making your strip look really professional.

The plot

Start by thinking up a plot. Try and keep it quite short. Make sure the story starts off with lots of action and ends with a strong punchline.

In a comic strip, the pictures are just as important as the text. They should be action-packed and exciting to look at.

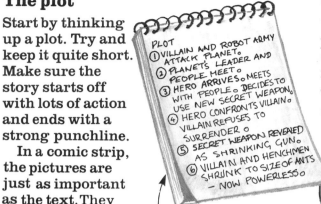

This is the plot for the comic strip on the right-hand page.

Creating characters

You need to give your characters strong personalities and draw them with slightly exaggerated features so they are easy to recognize in each frame. Here are the main characters in the comic strip on the right.

The hero

The villain

This is Captain Kovac, the hero of the story.

This is his arch-enemy, the evil Suberon.

Frames

The events in a comic strip are split into episodes and a picture is drawn for each one. These are called frames.

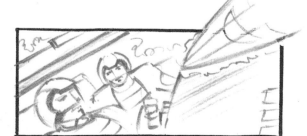

You can draw box rules freehand or use a ruler.

First, sketch out your ideas for each frame and draw in the boxes. You may need to try out several ideas. Add details to your sketches.

Speech bubbles

Use bubbles for spoken words, thoughts, and even sound effects. Do the lettering in capital letters to make it easy to read.

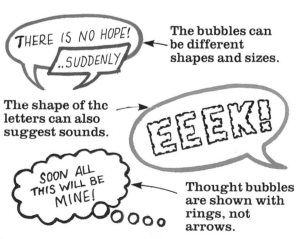

The bubbles can be different shapes and sizes.

The shape of the letters can also suggest sounds.

Thought bubbles are shown with rings, not arrows.

People read from left to right and top to bottom.

Here you can see how all the elements on the previous page are combined to make a comic strip. You can use the tips around the Dan Dare strip to help you make up your own.

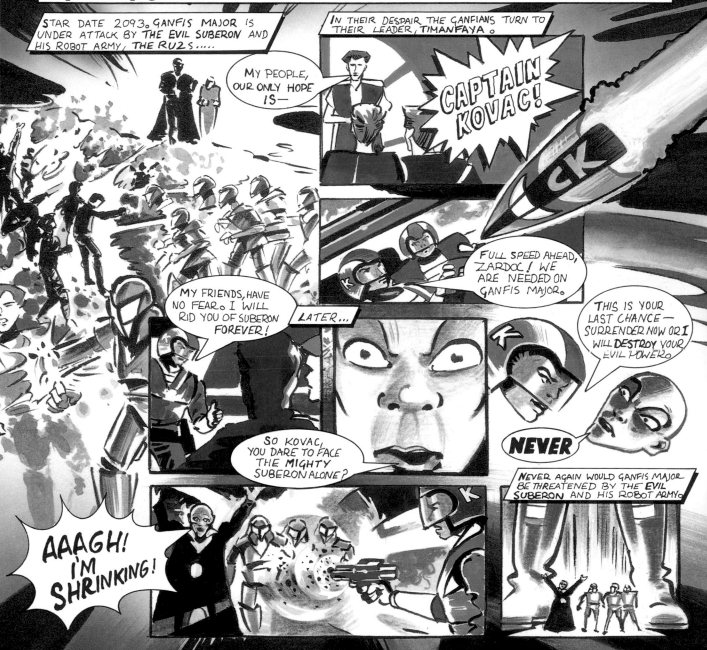

UFOs

Many people claim to have seen alien spacecraft shooting through the sky and even landing on Earth. These spacecraft are called UFOs, which stands for Unidentified Flying Objects. Some can be explained scientifically; others cannot.

UFOs come in many shapes and forms. On these pages there are just a few suggestions . . .

Flying saucers

The most common type of UFO is called a flying saucer. Not all flying saucers are saucer-shaped, though. They can also be torpedo-shaped or look like balls or spheres of light.

Use the outline shape below to help you draw a flying saucer.

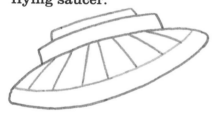

Add more details, such as windows round the side and lights underneath the body. Color the saucer in watercolor as shown here, or in pencil crayon.

Draw the saucer bathed in a strange yellow light.

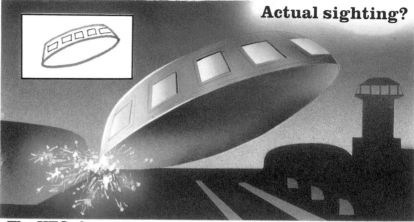

Actual sighting?

The UFO above was reported in Marseilles, France in October 1952 at 2 a.m. A pale blue light shone from its windows and sparks showered from one end. Use the outline to help you draw it.

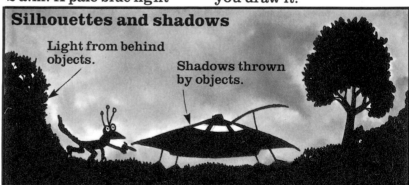

Silhouettes and shadows

Light from behind objects.

Shadows thrown by objects.

Silhouettes are an effective way of creating an eerie look to your UFO pictures. Imagine a strong light from behind trees, spacecraft or even alien figures. Draw the outlines of the shadows in pencil, then fill in the shapes with black felt tip pen or ink. Make the background quite pale to give a good contrast.

Fact or fiction?

Many supposed UFOs turn out to be airplane lights, parachutes, kites or even low clouds.

Here you can get some ideas for drawing UFOs based on familiar objects.

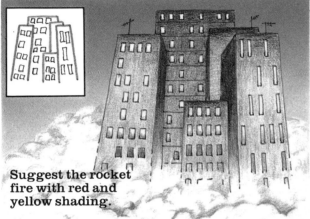

Suggest the rocket fire with red and yellow shading.

Try turning a block of flats into a UFO. First draw the outline shape in the box above, then turn the windows into lights and add billowing clouds of smoke.

An iron-shaped UFO was reported landing twice near Loch Ness, Scotland in 1971. The second time, three figures climbed on board.

The Tardis

In Dr Who, a famous British television program, the Doctor flies through space in the Tardis, shown below. On the outside it looks like an old-fashioned police box but inside it is a huge time machine.*

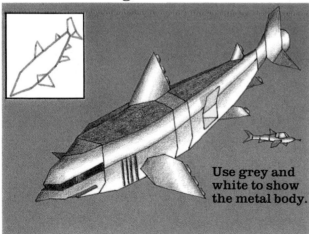

Use grey and white to show the metal body.

A shark's shape makes a good UFO. Give the basic fish shape strong angles. Use pencil crayons to color it in.

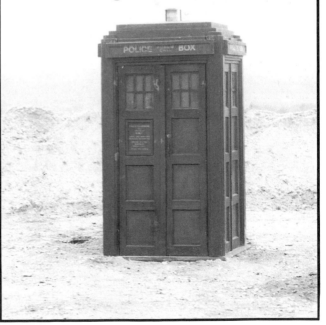

*Photograph © BBC.

Mix and match

Here are suggestions for some cartoon spacecraft, astronauts and aliens to add to your space scenes. Draw the aliens using different combinations of heads, bodies and legs, and add your own ideas to the spacecraft and astronauts.

Spacecraft

Using some of the basic shapes for the real spacecraft shown in this book, you can make up machines like the ones below.

Color them any way you like and add extra details like lights, engines, wing and tail fins and smoke trails.

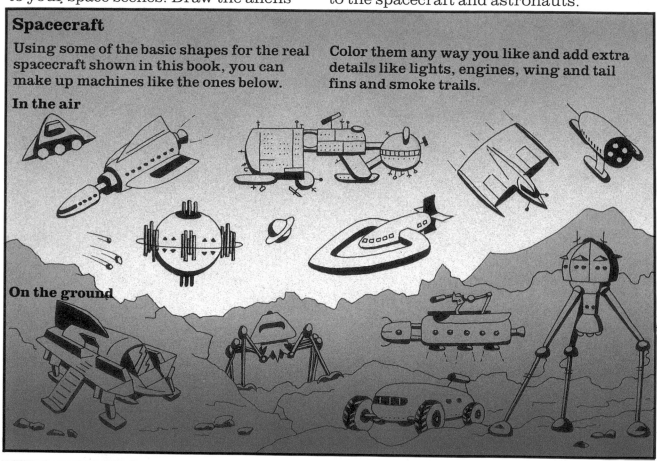

In the air

On the ground

Logos

Here are some ideas for logos* to add to spacecraft, or even spacesuits. You could invent your own logos, basing the design on your initials, for example.

*A logo is a manufacturer's emblem.

Aliens

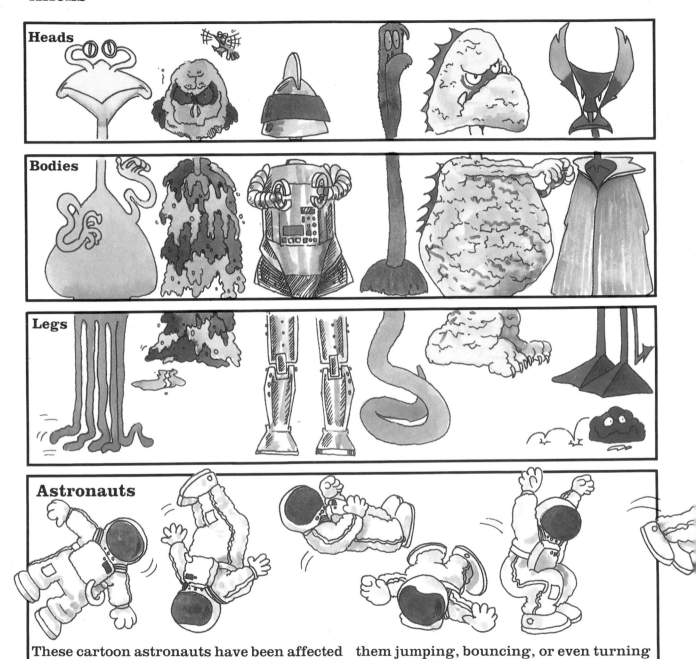

Heads

Bodies

Legs

Astronauts

These cartoon astronauts have been affected by the low gravity on the Moon.* Draw them jumping, bouncing, or even turning somersaults in your pictures.

*See pages 16-17 for more about the Moon.

Index

First published in 1988 by Usborne Publishing Ltd,
Usborne House, 83-85 Saffron Hill, London EC1N 8RT.

Copyright © Usborne Publishing Ltd, 1988

The name Usborne and the device are Trade Marks of
Usborne Publishing Ltd.

Printed in Belgium American edition 1988.